18th Century. Vignettes by Watteau PLATE 1

18th Century. Ornamental border by Peyrotte PLATE 2

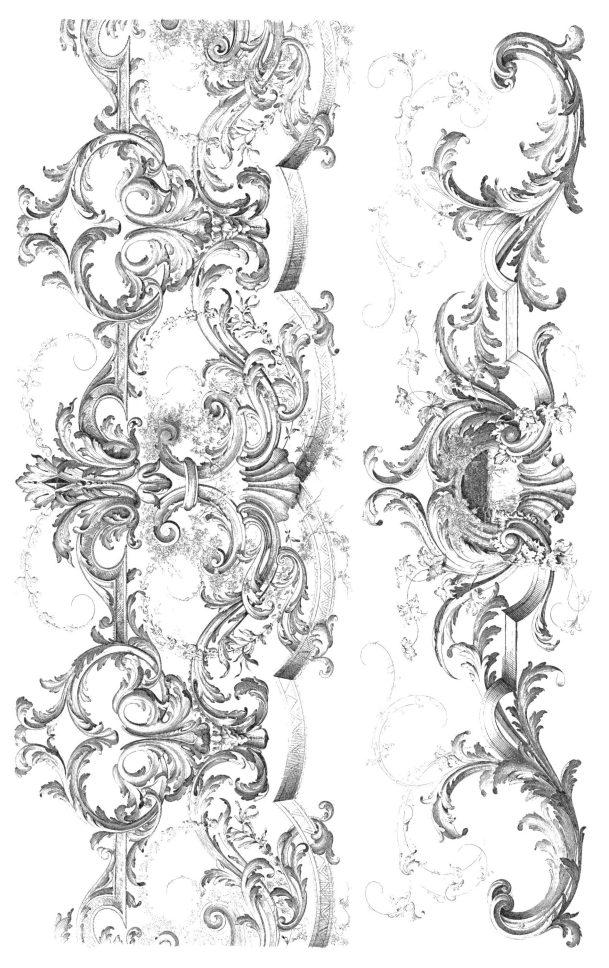

18th Century. Ornamental border by Peyrotte PLATE 3

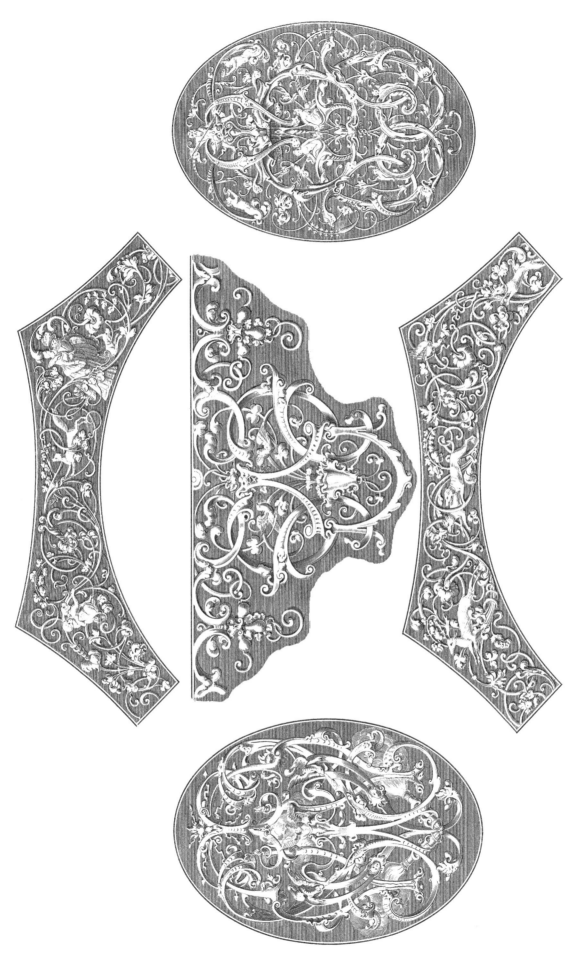

17th Century. Italian ornaments by Janssen PLATE 4

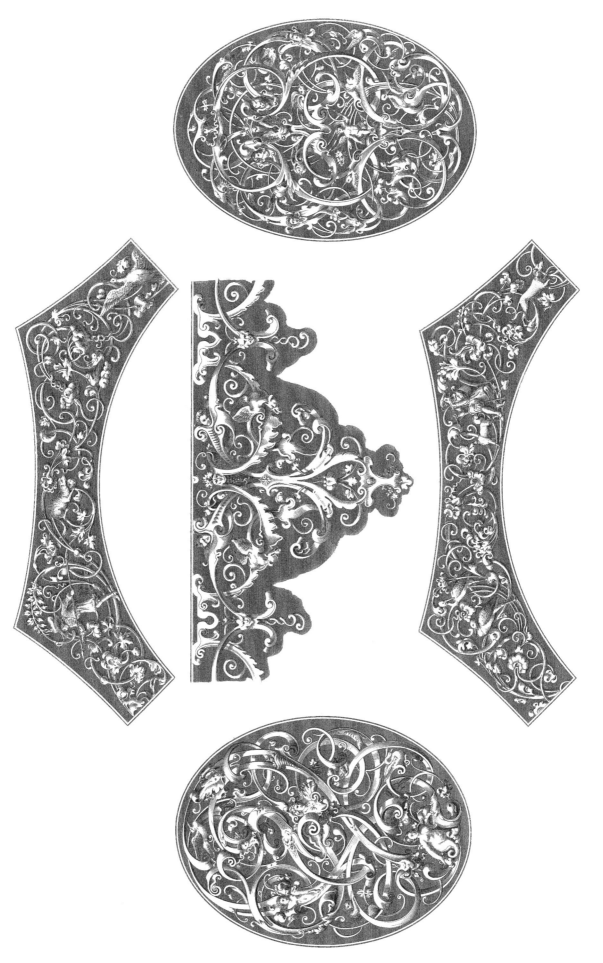

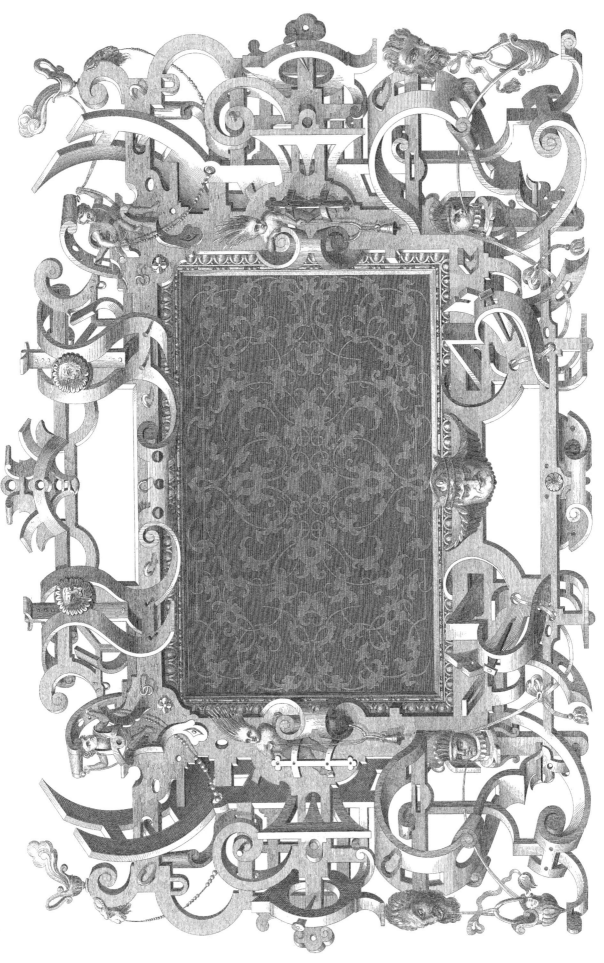

16th Century. Italian design by Vriese PLATE 6

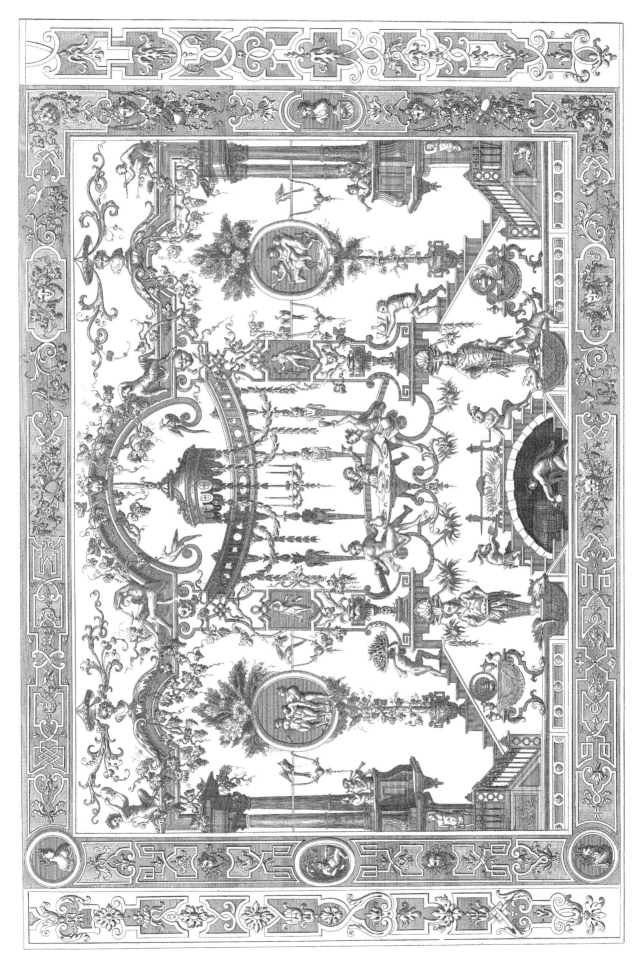

17th Century. Decoration in grotesque style by Berain PLATE 7

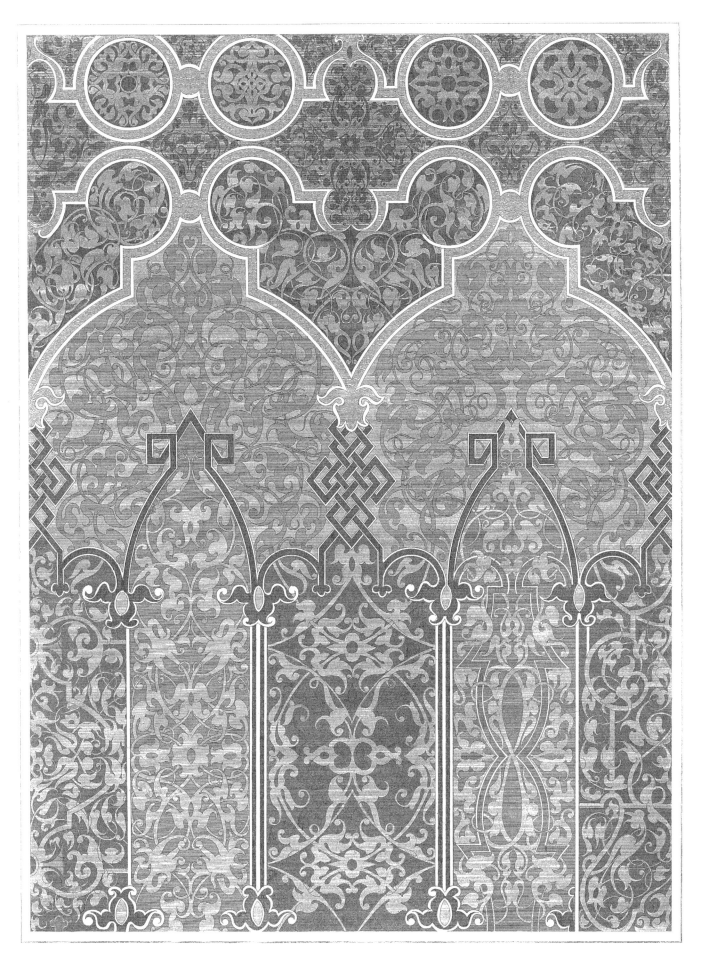

16th Century. Wall decoration, unknown artist PLATE 8

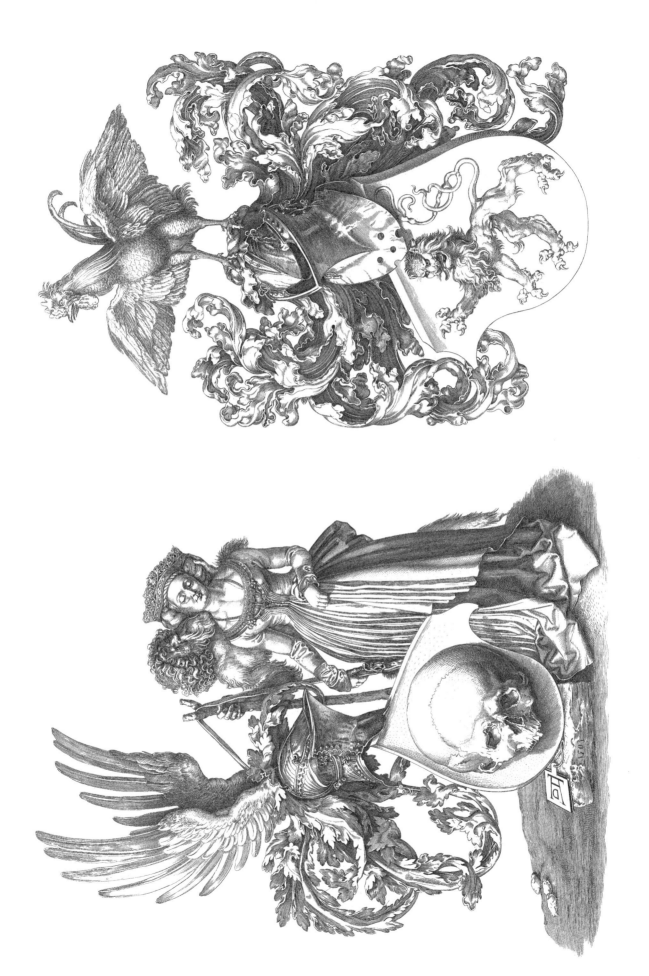

16th Century. Two shields of arms, with figures, by Albert Durer PLATE 9

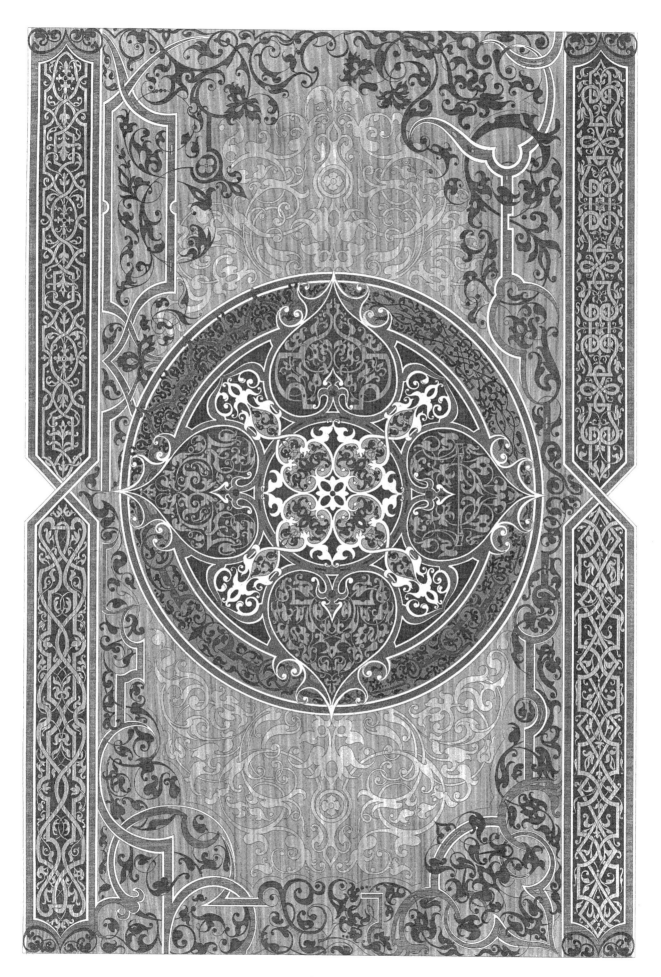

16th Century. Design for inlaying woods, etc. by Virgile Solis PLATE 10

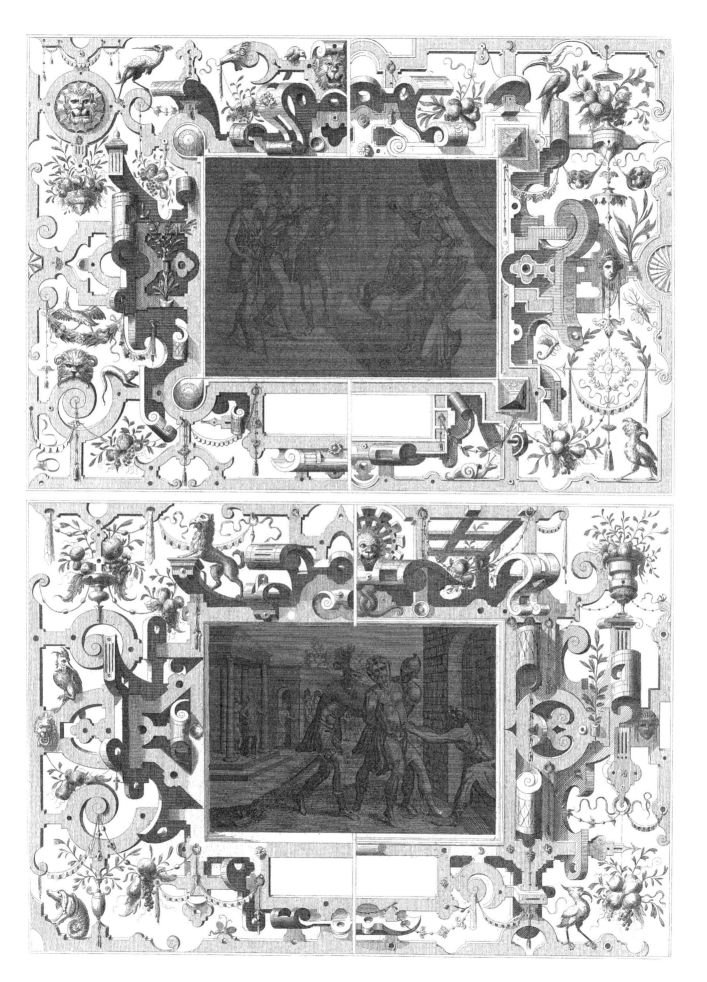

16th Century. Wall decoration, historical subjects, unknown artist PLATE 11

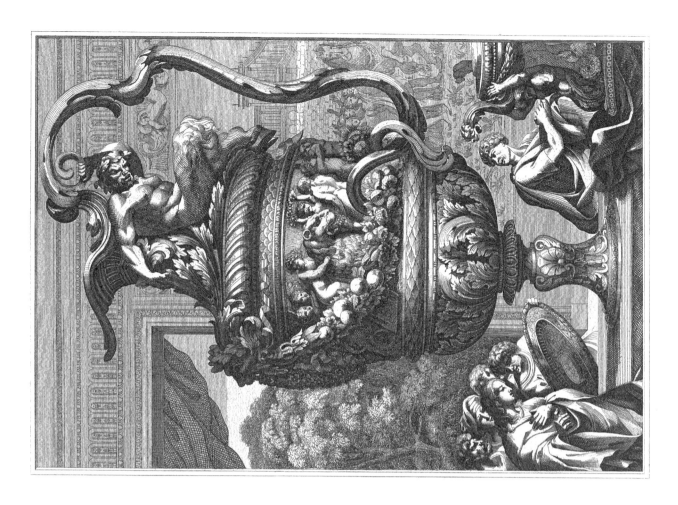

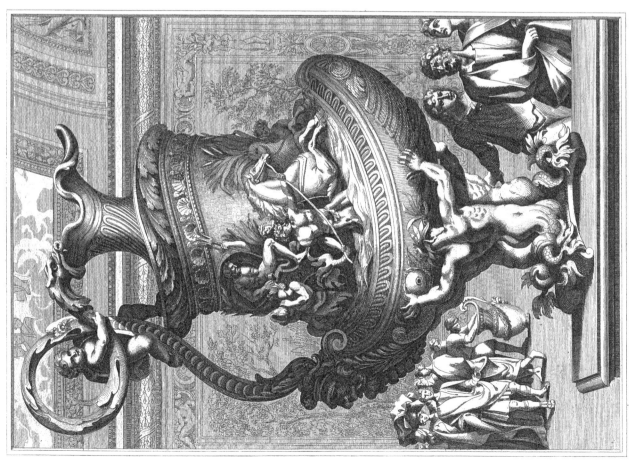

17th Century. Two architectural vases by Lepôtre PLATE 12

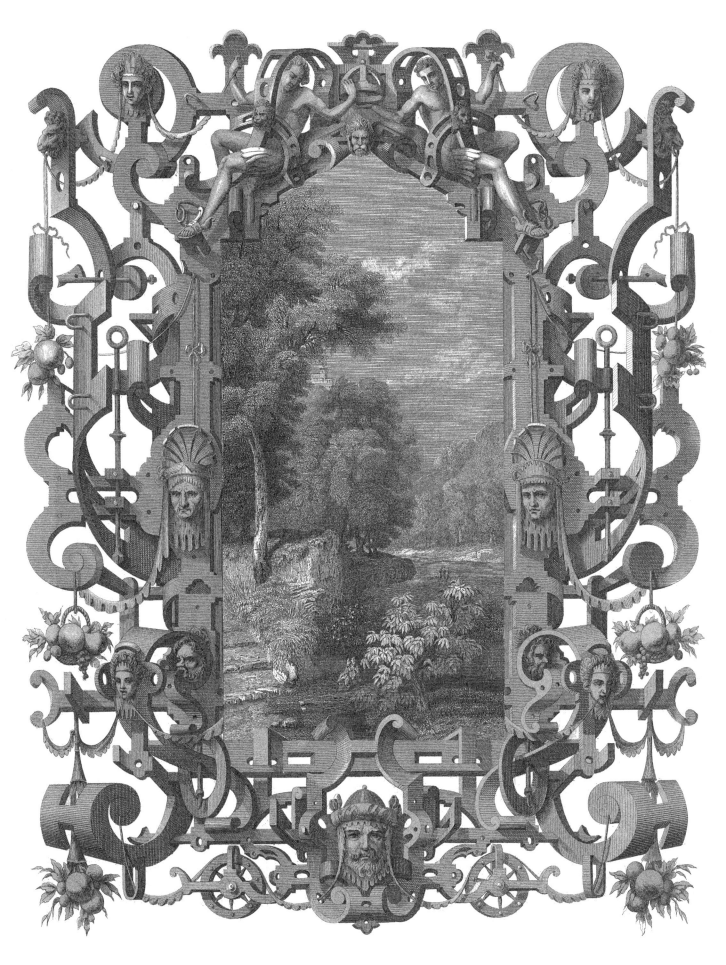

16th Century. Wall decoration, with landscape, by Vriese PLATE 13

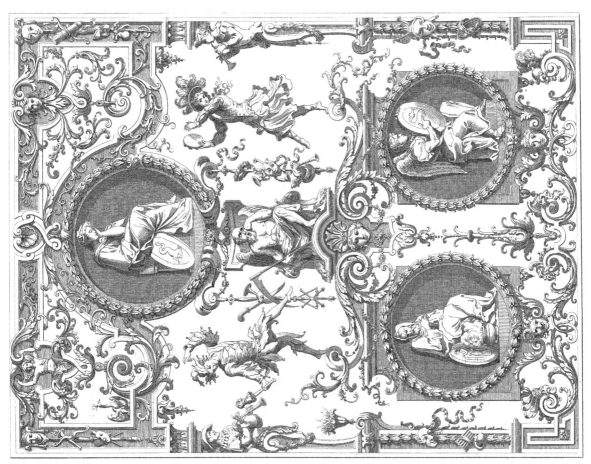

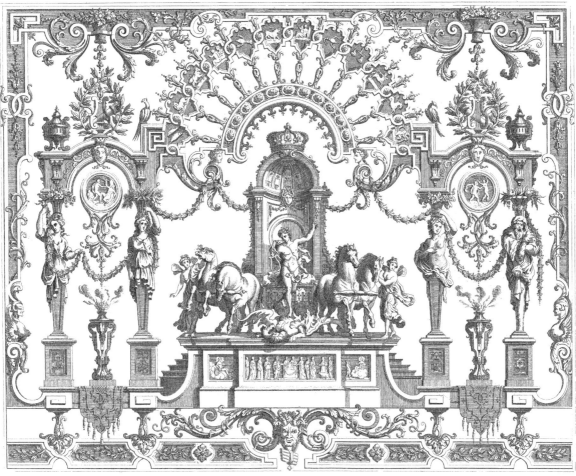

17th Century. Wall decoration by Berain PLATE 14

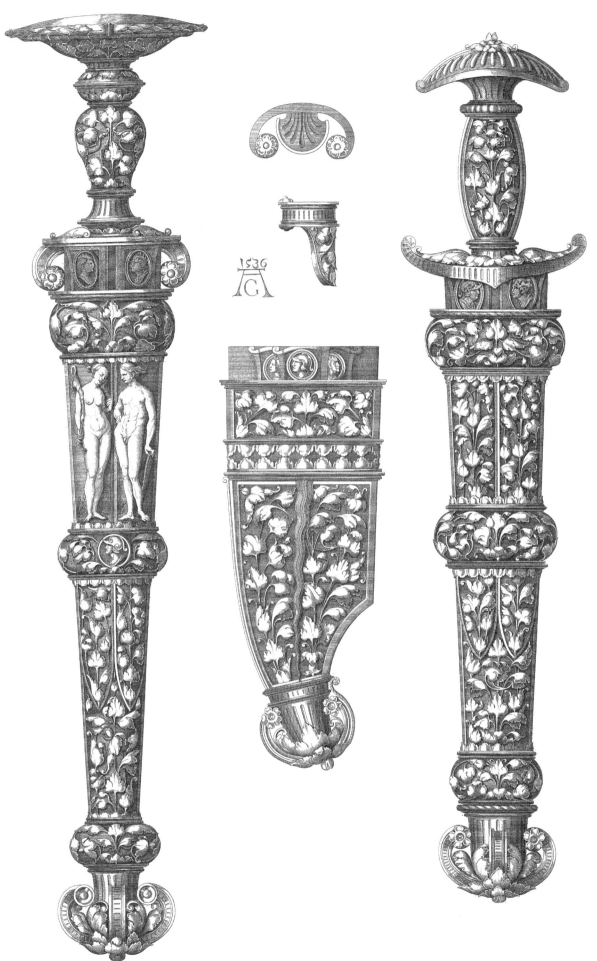

16th Century. Dagger and sheath, cased work, by Aldegrever PLATE 15

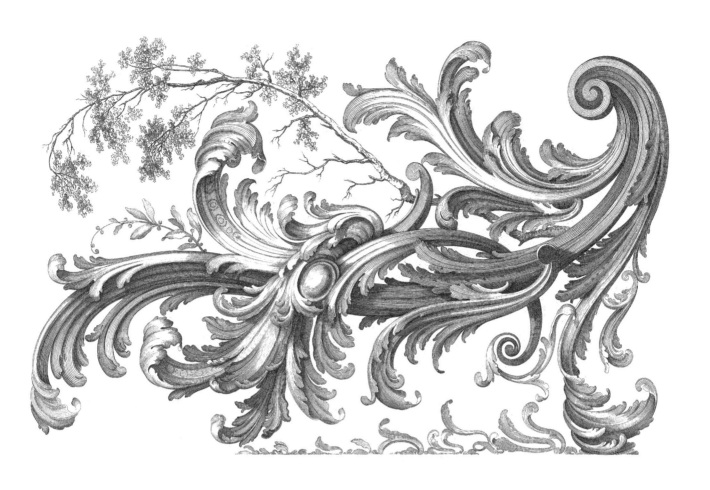

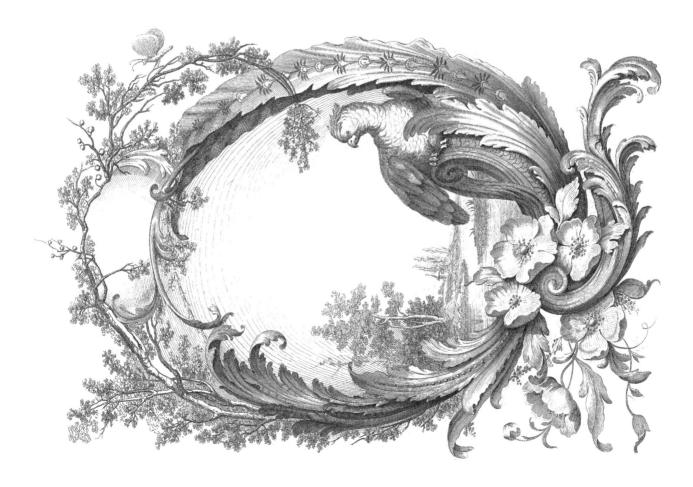

18th Century. Wall decorations by Peyrotte PLATE 16

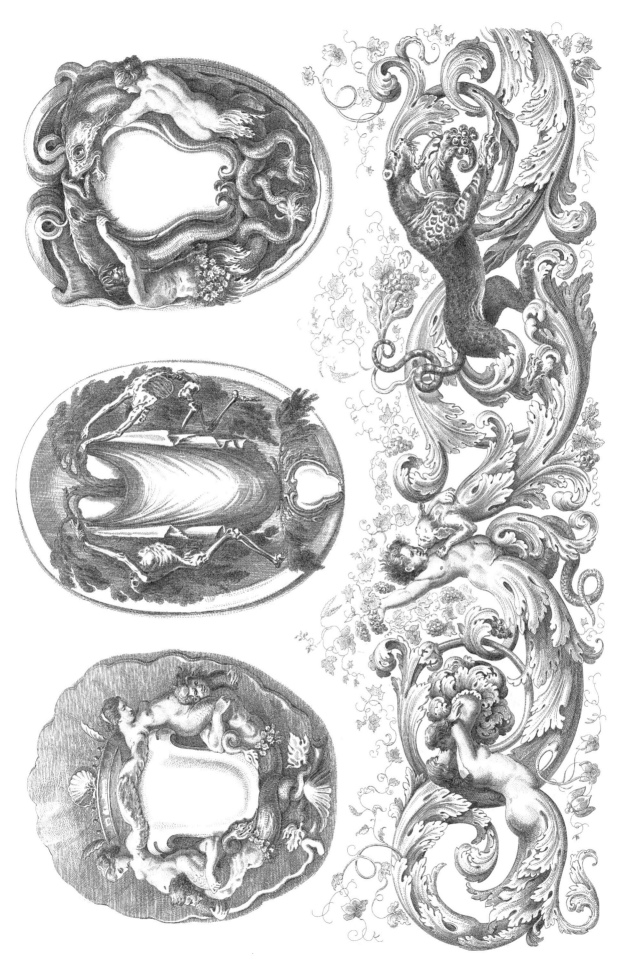

17th Century. Border and escutcheons by J. D. Bella PLATE 17

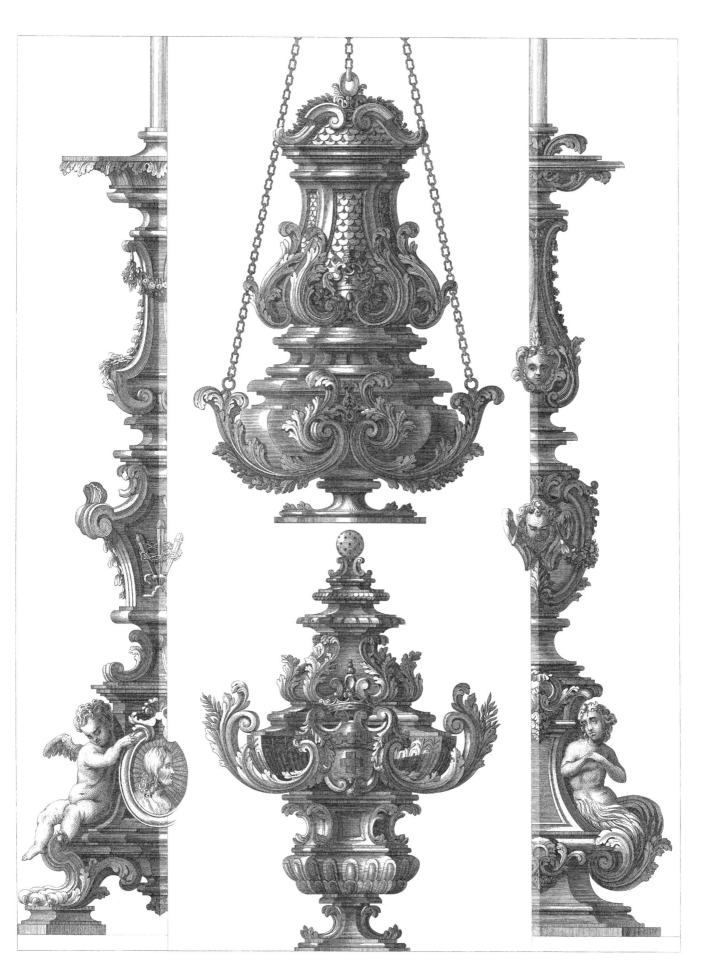

18th Century. Vase, lamp, and pedestal by J. Giardini PLATE 18

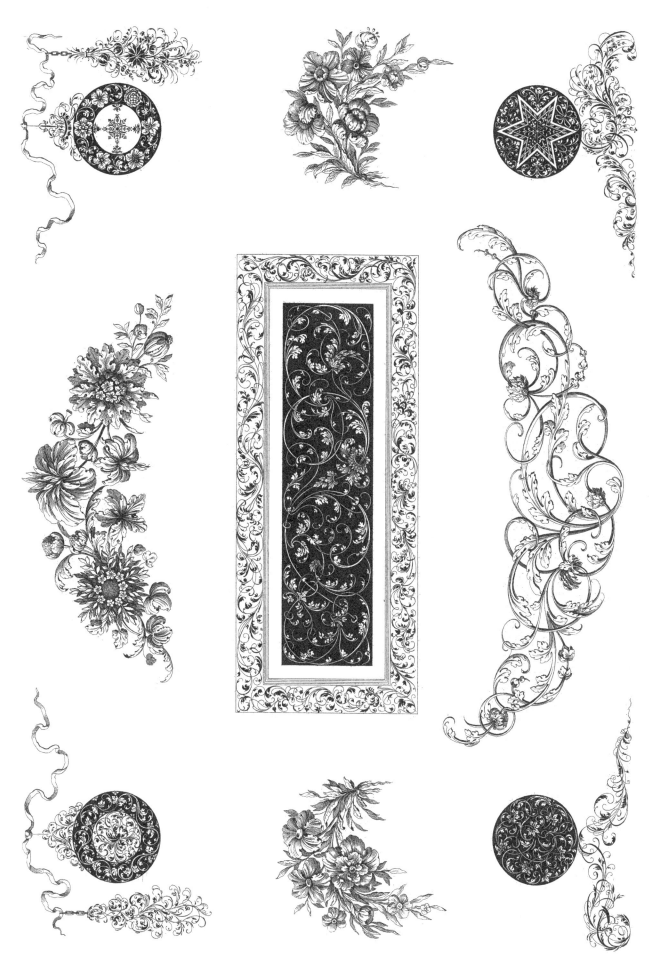

17ᵗʰ Century. Examples of engraving by Morisson PLATE 19

16th Century. Alphabet of capital letters, A to F, by Theodore de Brie PLATE 20

16th Century. Alphabet of capital letters, G to M, by Theodore de Brie Plate 21

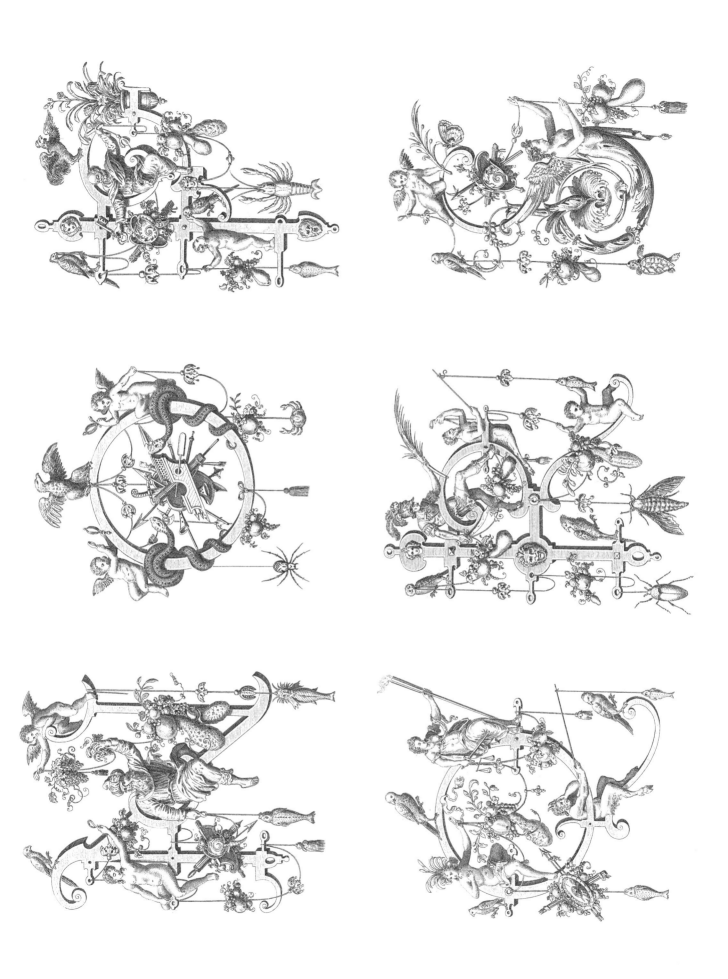

16th Century. Alphabet of capital letters, N to S, by Theodore de Brie PLATE 22

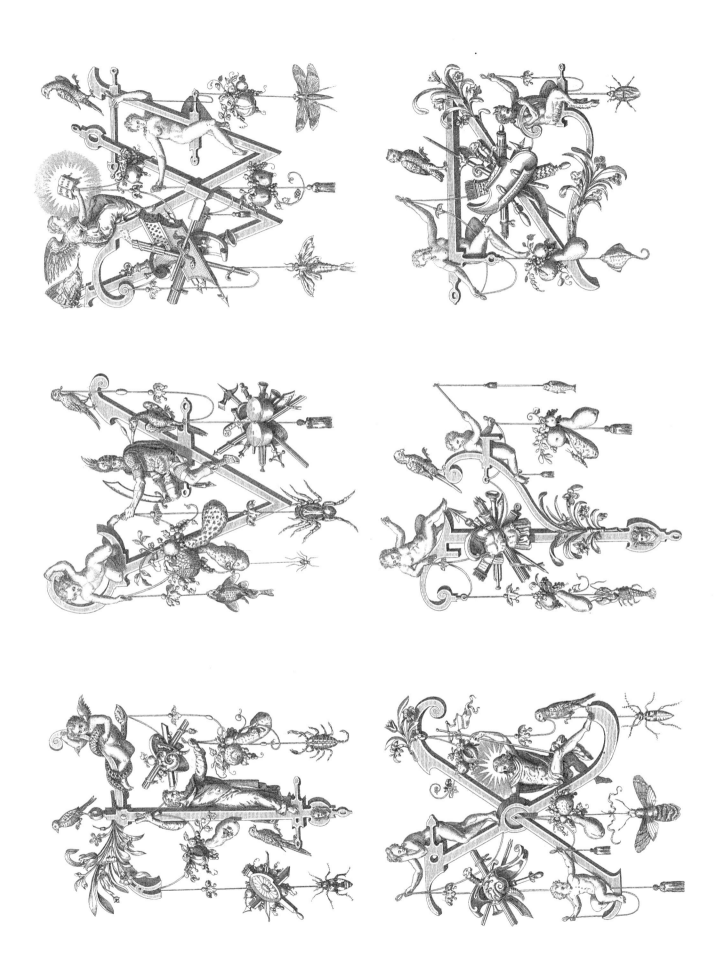

16th Century. Alphabet of capital letters, T to Z, by Theodore de Brie PLATE 23

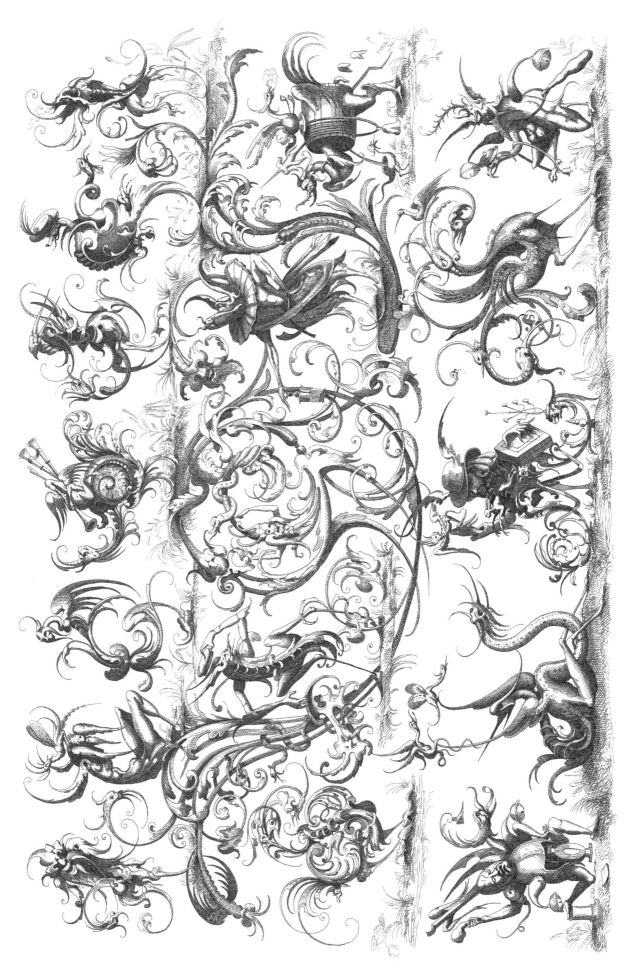

17th Century. Grotesque by unknown artist, possibly Callot PLATE 24

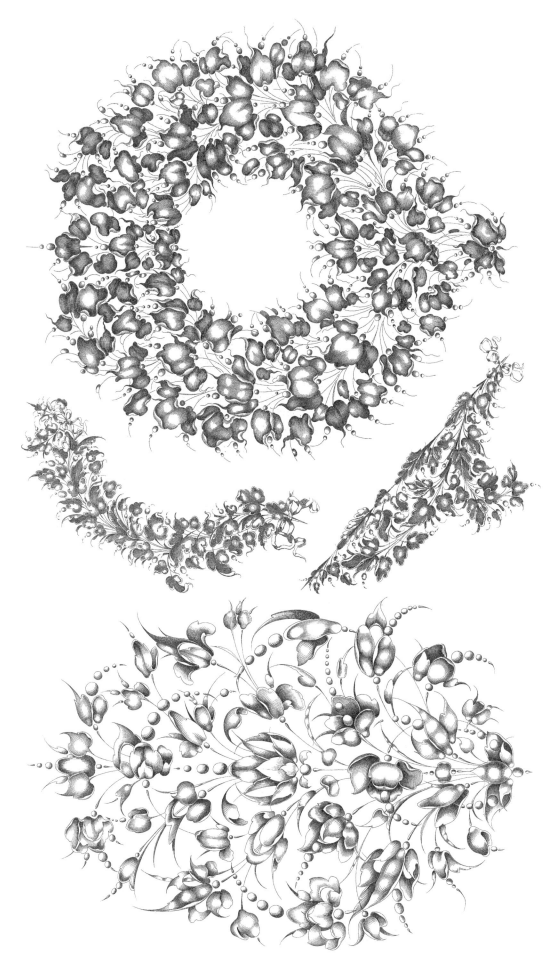

17th Century. Ornaments suitable for wood carving, by Gedéon l'Égaré et Pierre Bouquet PLATE 25

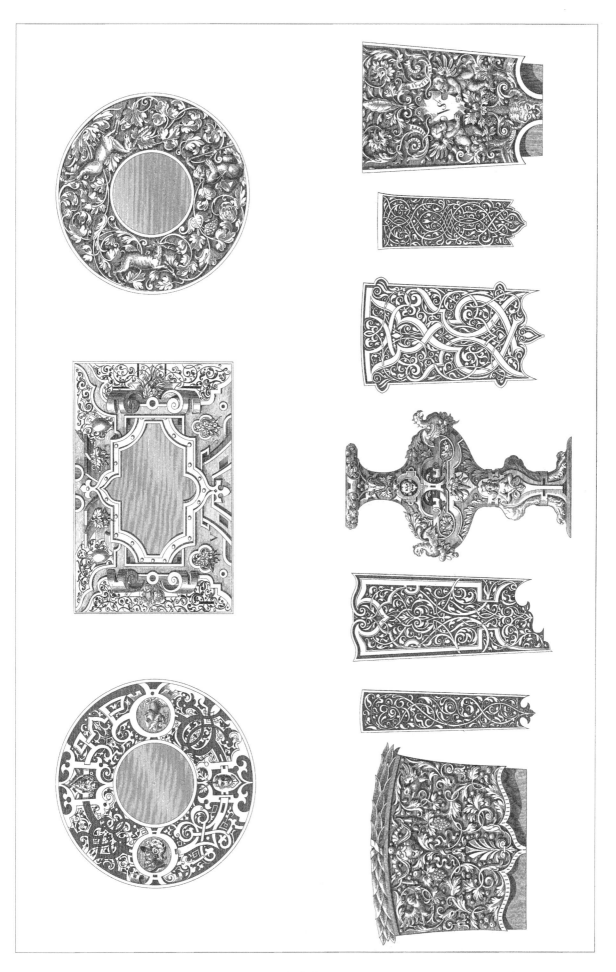

16th Century. Examples of Engraving by Virgilius PLATE 26

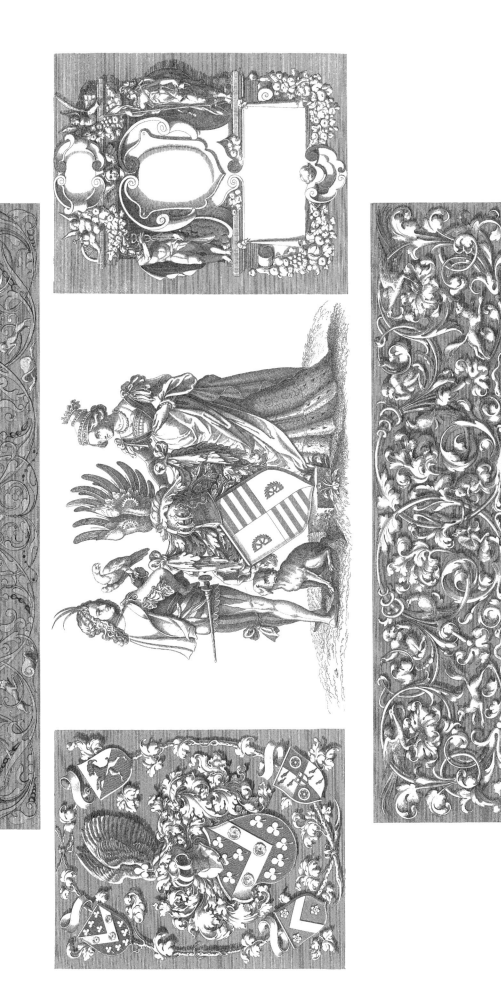

17th Century. Shields of arms, with figures and other ornaments, by Blondus PLATE 27

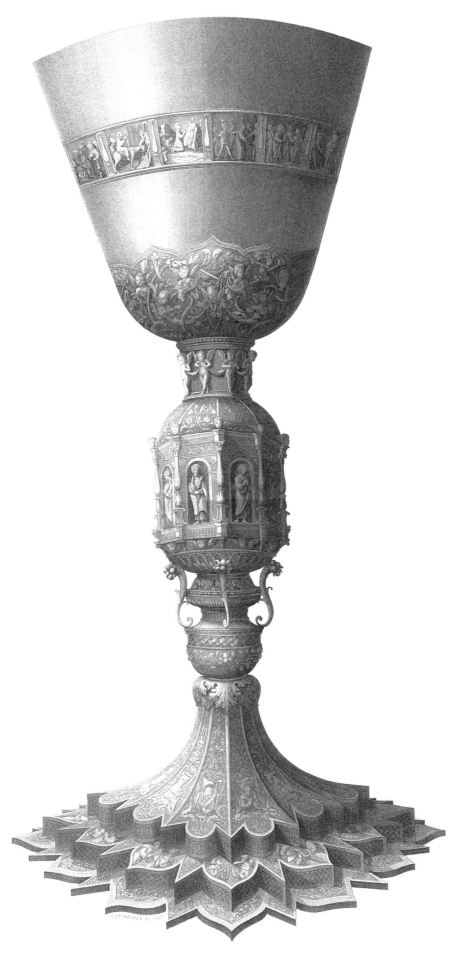

17th Century. Chalice, chased, by Andréa Mantenio PLATE 28

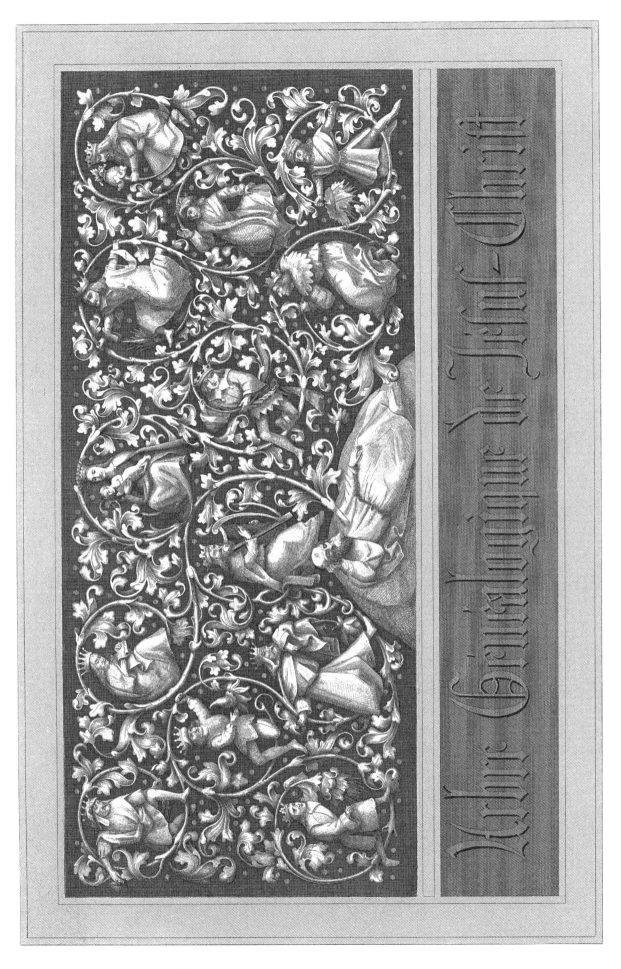

15th Century. Genealogical Tree of Jesus Christ by Israël van Mecken PLATE 29

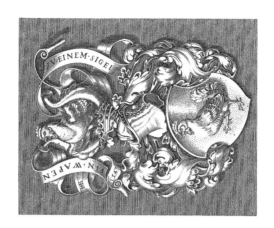

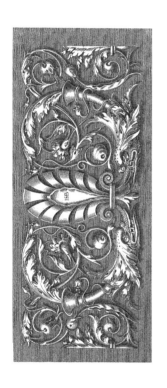

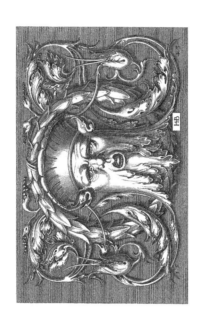

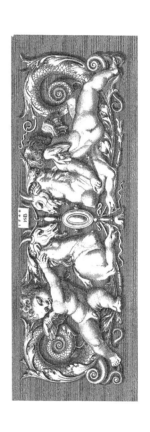

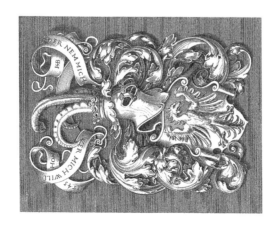

16th Century. Shields of armor, with ornaments by Hans Beham PLATE 30

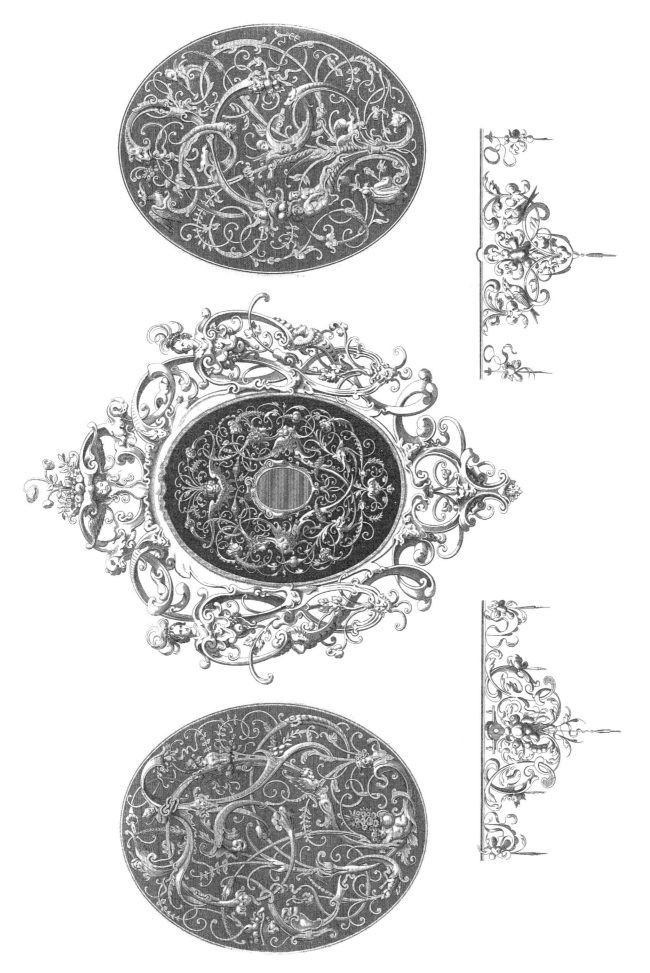

17th Century. Italian ornaments by Janssen PLATE 31

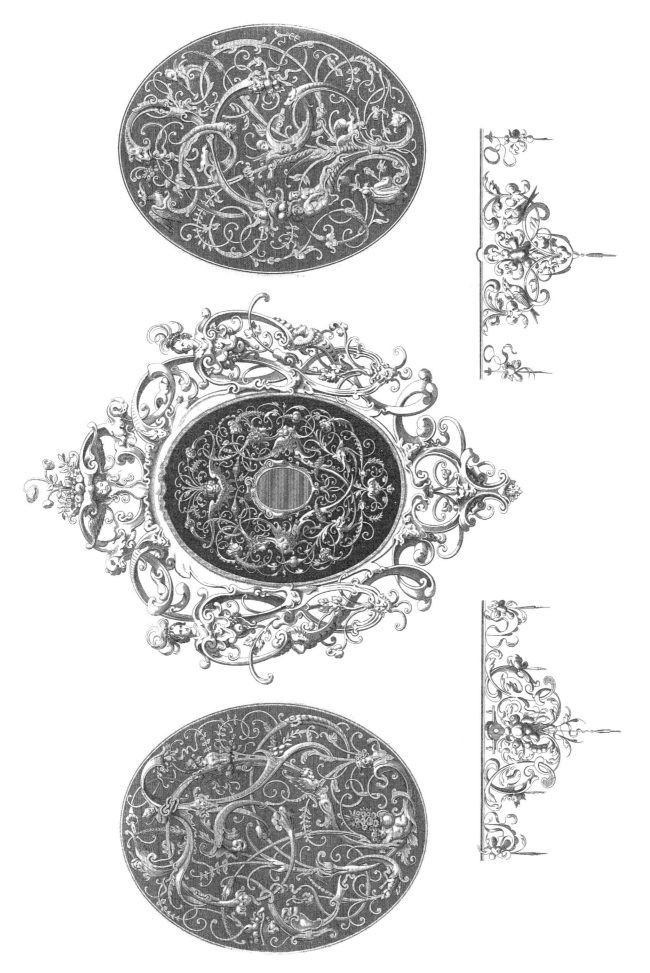

17th Century. Italian ornaments by Janssen PLATE 31

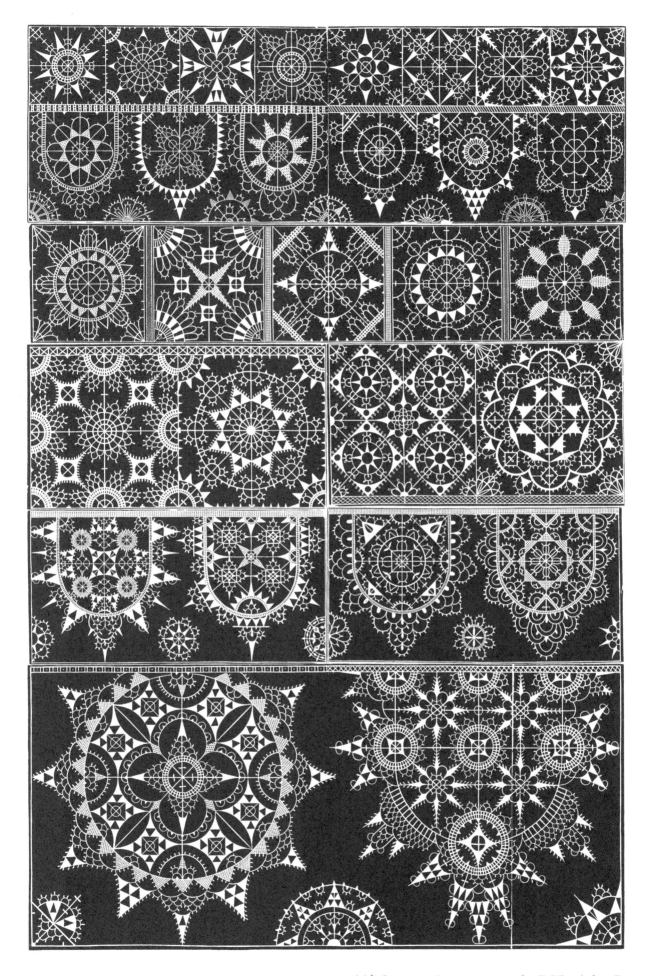

16th Century. Lace patterns by F. Vinciolo PLATE 32